MY ART TEACHER, MR MATISSE

An Hachette UK Company
www.hachette.co.uk

First published in Great Britain in 2018
by Ilex, an imprint of
Octopus Publishing Group Ltd
Carmelite House
50 Victoria Embankment
London, EC4Y 0DZ
www.octopusbooks.co.uk

Distributed in the US by Hachette
Book Group, 1290 Avenue of the Americas,
4th & 5th Floors
New York, NY 10104

Distributed in Canada by Canadian
Manda Group, 664 Annette St., Toronto,
Ontario, Canada M6S 2C8

Editorial Directors: Zara Larcombe
and Helen Rochester
Commissioning Editor: Zara Anvari
Managing Editor: Frank Gallaugher
Editor: Jenny Dye
Publishing Assistant:
Stephanie Hetherington
Art Director: Julie Weir
Designer: Louise Evans
Picture Research: Giulia Hetherington
and Jennifer Veall
Production Controller: Katie Jarvis

ISBN 978-1-78157-550-5

A CIP catalogue record for this book
is available from the British Library

Printed and bound in China

10 9 8 7 6 5 4 3 2 1

MY ART TEACHER, MR MATISSE

Creative activities inspired
by the master of color

Liana Jegers

ilex

CONTENTS

INTRODUCTION

Henri Matisse (31 December 1869—3 November 1954)
could not help but paint—it was his air. But
painting did not always come easily to him, and he
was constantly practicing and experimenting to find
the styles and techniques that suited him best.
While he is so well-known for his paintings, Matisse
also pursued many other forms of artistic expression,
such as drawing, printmaking, sculpture, decorative
design, and the large-scale paper collages that
he produced at the end of his career. His theories
on color and form helped shape contemporary art,
influencing generations of artists and thinkers
along the way.

Exploring Matisse's favorite subjects and mediums,
and guiding you to try out the artist's innovative
techniques, this book will inspire you to come into
your own style with help from the master. Matisse's
work is not meant to be copied—rather, his ideas and
methods will help you to think differently and can be
applied to much more than what these pages contain.
When you feel inspired, or after completing these
exercises, test out different materials such as inks,
paints, and oil pastels; try different surfaces such
as ceramics, fabrics, and canvas; and learn to take
a moment to interpret the world around you with
energy and emotion.

"

WHAT I AM AFTER, ABOVE ALL, IS EXPRESSION

"

HENRI MATISSE

THE FACE OF FAUVISM

Exhibiting with a group of like-minded painters
in 1905, Matisse helped to launch Fauvism. These
artists experimented with vibrant colors and bold
brushstrokes to express their subjects, and they
borrowed from several different pioneering
movements and synthesized these influences. From
Post-Impressionism, Matisse discovered his passion
for pure color; from Pointillism, a desire for
harmony, new techniques, and structure; from
Symbolism, how to reflect on an inner truth and
feeling; from African sculpture, a desire for a
new purity of form and large flat planes.

As with most innovative movements, the group's first
show shocked the critics and public alike. Dubbed
"les fauves" (meaning "wild beasts", because they had
released themselves from the confines of traditional
painting techniques), the circle often used paint
straight from the tube instead of mixing to achieve
realistic colors. Their color choice was reactionary—
whatever they felt as they looked at a landscape or
a person sitting for a portrait, they expressed in
their work, and they didn't concern themselves with
intricate details.

In this chapter we will explore several different
ways Matisse made portraits, learning how he built
new methods from his old techniques, stripped
everything down to the essential information, and
used color theories to further push his ideas.

MARK-MAKING

Looking at himself in a mirror and painting what
he saw provided Matisse with time for introspection
and interpretation. How would his inner emotions be
interpreted through dramatic lighting, the tilt
of his head, or a furrowed brow?

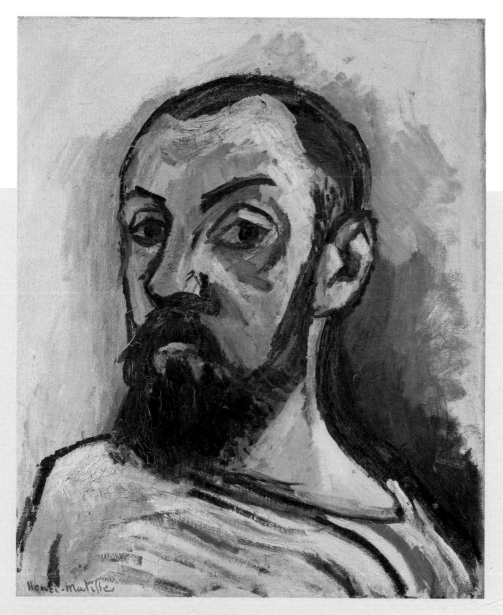

SELF-PORTRAIT IN A STRIPED T-SHIRT
1906, Oil on canvas

In this work, Matisse uses a brush and black
ink to create a quick and expressive portrait.
His focus was to draw the key features of the
face as quickly as possible, trusting his
instincts when it came to simplification.

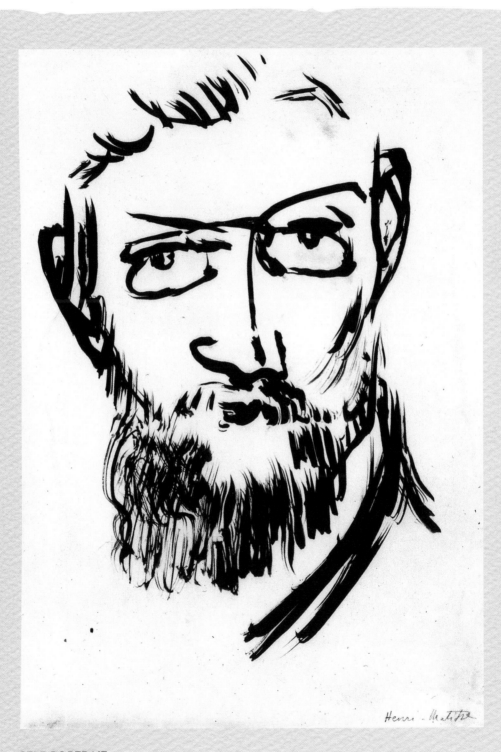

SELF-PORTRAIT
1900, Ink on paper

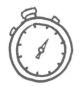 Practice drawing your own self-portrait. Setting a time
constraint will help you to distill your face down its
essential elements. Notice how unnecessary details are
gone by the final portrait in the examples below.

1 MINUTE

3 MINUTES

30 SECONDS

Looking in a mirror, study your face, and notice the key characteristics that make it unique. Pay close attention to the shape of your nose, eyebrows, and mouth. Setting a timer for the amount of time shown by the prompts on these next pages, transpose your image on paper.

3 MINUTES

1 MINUTE

You have only 60 seconds to draw yourself this time.
Use quick, broad strokes and select six of your most
distinguishing features to draw, one per ten seconds.
Draw from your fingers for shorter strokes and from
your wrist for longer, more rounded marks.

30 SECONDS

Thirty seconds will pass by quicker than you think!
Allow yourself to draw spontaneously. Rather than selecting
consciously, simply wait to see the result. Don't worry about
making your portrait look realistic as you are trying to
simplify the face into a few quick strokes or marks.

Now practice drawing yourself from lots of different angles.
Focus on the shape of your head. Look to the side to draw
yourself in profile, or tilt your head down for a more dramatic
angle. Take no more than a few minutes for each portrait.

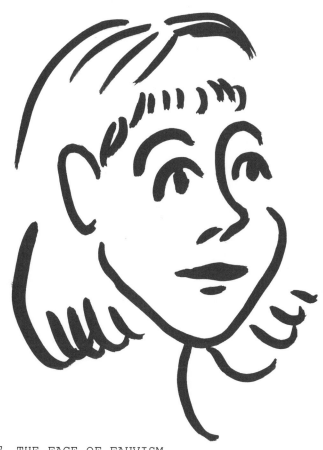

An economy of line is important: use a limited number
of strokes of different lengths—heavy, thin, short,
and continuous. Create marks at different speeds,
and remember to focus on your key features.

To help your hands begin communicating with each other, drawing blind
is a helpful exercise. Ask a friend to sit for you and place yourself
immediately in front of them. Close your eyes, and using your free hand,
feel the different contours of your friend's face and simultaneously
note down the different sensations: softness, stubble, lips, etc.
Use different pencil pressures to denote these various feelings.

It is very easy to critique our work before we have even finished it.
To free yourself from these inhibitions, draw your sitter without looking
down at the page. Try not to remove your pen or pencil from the paper.
Keep your gaze on your friend and notice their different features.
See what you can note down in two minutes, one minute and 30 seconds.

USING COLOR

An artist's palette is a powerful tool, and different colors can create different impressions on the viewer. In his painting, *Portrait of Lydia Delectorskaya*, Matisse has split the face into two halves, filling either side with flat colors. Using only a handful of colors and unapologetic black outlines, Matisse has captured the essential features and attitude of his sitter.

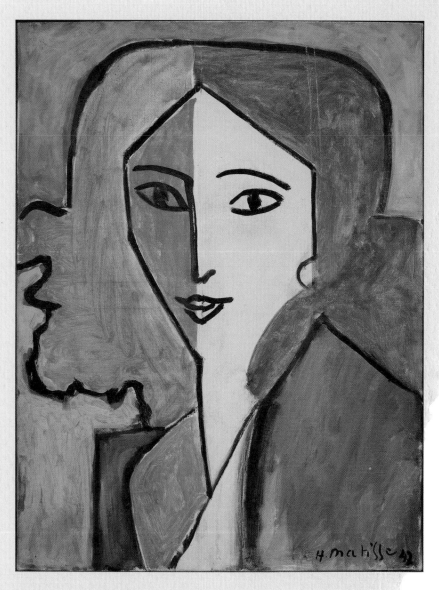

PORTRAIT OF LYDIA DELECTORSKAYA
1947, Oil on canvas

The exercises on the next pages will help you create portraits using limited color palettes. You will be surprised how much can be conveyed using just a few colors.

Create a self-portrait using four different shades of the same color.
These don't have to be realistic flesh tones—try using shades of blue
or green, for example. Fill these circles with the palette you will
be using so you can refer back to it.

Start by outlining and filling the shape of your face
with your lightest color. Layer the other colors onto
the page, mapping out the different areas of your face
in the shades that are most appropriate for each.

Now create another color palette and self-portrait, this
time using just two shades of the same color. Which areas of
your face will fall into the lighter shade, and which into
the darker? This will help you simplify your portrait even
more as you will need to make choices about which of the two
colors is the best choice for each area of your face.

For this portrait, add dramatic lighting by setting up a lamp on one side of your face. How do the shadows differ from one side to the other? Add thick black line to outline the two distinctive areas, and pick two colors to convey them. Pink, orange or yellow will imply light, while colors such as blue, green, and purple will imply shadow.

Matisse's *Woman with a Hat* was heavily criticized
when first displayed in 1905. By this time, his early
experiments in Pointillism, where a scene was made
using tiny dots of color, had given way to the long,
bold, confident strokes that you can see below. Using
a mix of pastels and pure colors, Matisse creates a
sense of space and physicality by building up areas
of color and through each mass of strokes.

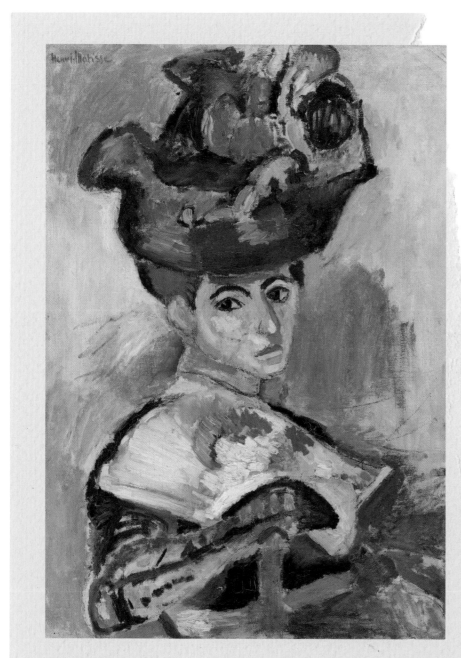

WOMAN WITH A HAT
1905, Oil on canvas

You can build up multiple pencil
or pastel strokes of color to
create an expressive portrait,
much like this example. Use
the next two pages to try this
technique for yourself.

Map out distinct areas of color with lots
of strokes. Instead of blending your colors
together, allow the marks left by the medium
you're using to show. Sample different shades
of one color to create darker, lighter,
louder, and quieter areas. Only color areas
near your sitter; here, the background is
designed only to complement the portrait.

Matisse chose materials that would further express
what he saw or felt. Using colored pencils with a
fine point will give you more control, but pastels
or markers with brush points will create a looser,
more expressive drawing. Experiment with different
materials to find the right tools for you.

COLOR THEORY

The Fauves often used complemetary colors, or those opposite on the color wheel, which made the paint and the canvas appear brighter and more vibrant.

A basic color wheel looks like this, with the three primary colors indicated by points of the triangle. These three colors (blue, red, and yellow) are pure, meaning that you can't mix together any other colors to achieve them.

The other colors are known as secondary colors. You can make them by combining any two primary colors. A simple way to find a color's complement is to look at which color is directly across from it on the wheel.

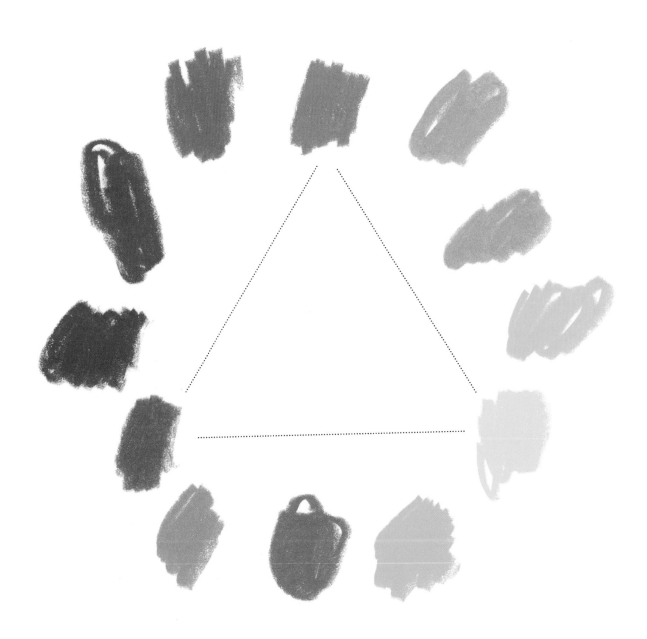

Colors close together on the color wheel will
feel in harmony with one another (such as red,
blue, and purple), while colors on opposite sides
(such as red and green) will compete with one
another—something Matisse used to his advantage.

Using any drawing materials
you like, add pairs of
complementary colors to the
circles, using the color wheel
opposite as a guide.

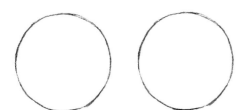

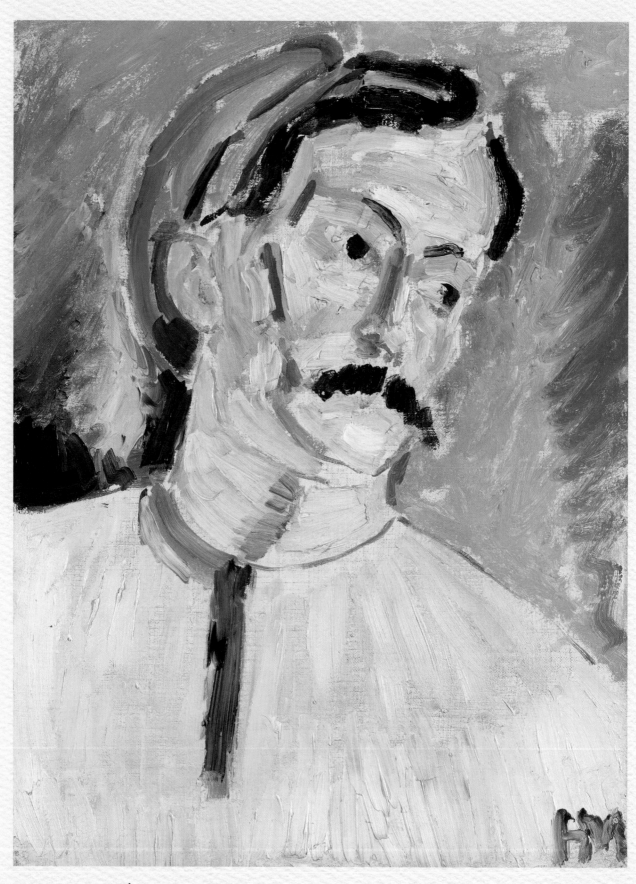

PORTRAIT OF ANDRÉ DERAIN, 1905, Oil on canvas

Looking at Matisse's portrait of friend and fellow Fauve André
Derain, one can see how he used color, in conjunction with
long, flat brushstrokes and marks, and a tilt of the head,
to make a rather neutral facial expression come to life.

He uses multiple sets of complementary colors—see how the
orange of Derain's face is offset by the blue next to it,
and the purple of his hat is complemented by the yellow of
his shirt.

This technique that Matisse utilized helped convey the true
emotion of the subject, rather than a faithful replica of what
he saw standing before him.

Putting into practice what you've just explored with
Matisse's color theory, create self-portraits by using
different color combinations. Pay attention to how you
can create energy through complementary colors, and
through your brushwork or linework.

First, use blue and
orange as the two
prominent colors.

Looking back at the color wheel to guide
you, make a new self-portrait using
multiple sets of complementary colors.

Portraits are designed to tell you about someone. Matisse
used brightly colored and patterned pieces of clothing
to explore his stylistic choices in his portraits, and
to tell the viewer more about the subject. In *The Red
Madras Headdress*, the bright, bold patterns on the model's
clothing capture the viewer's attention and are given as
much emphasis as the model herself.

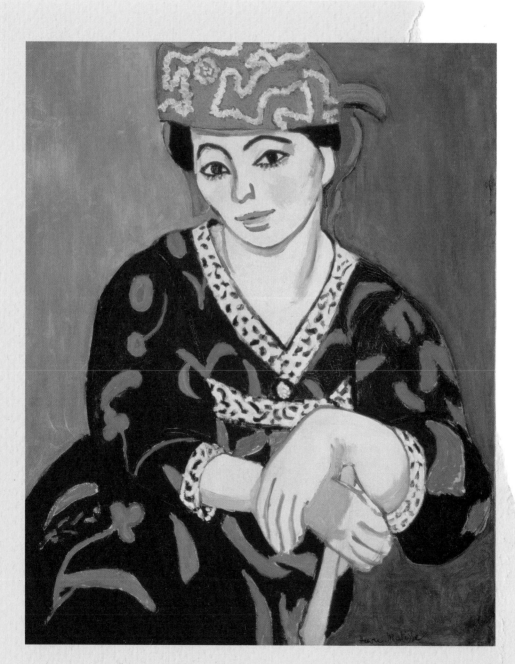

THE RED MADRAS HEADDRESS
1907, Oil on canvas

Create portraits on the next two pages of friends and family close to you. First, think about what their clothes say about them, and notice if they are wearing makeup and accessories. Include these details in your drawing—they show you how your sitter wants to be seen and portrayed.

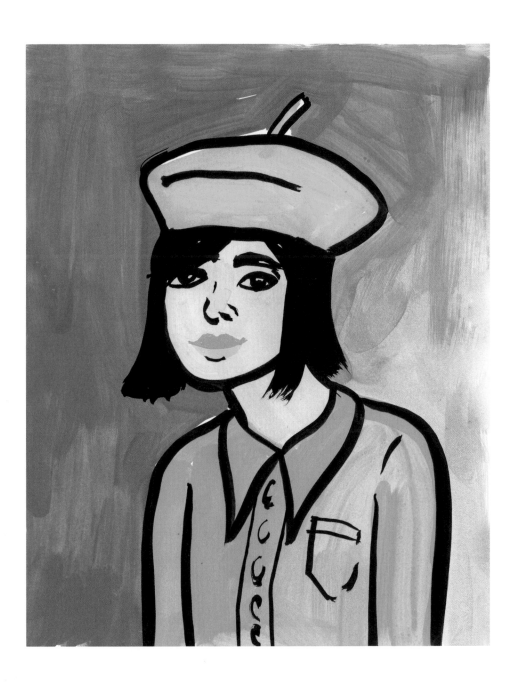

You can use color to help accentuate your
sitter's features and reflect their character.
Use red if they are passionate or to accentuate
their dark features or pale skin.

Bring energy to your work by adding a
contrasting background and use other
choice colors that relate to each other.

"

I AM SEEKING FORCES, AND A BALANCE OF FORCES

"

HENRI MATISSE

PATTERN

After taking several trips to Morocco and Spain,
Matisse became enamored with Islamic, North African,
and Moorish art. He felt a strong connection to the
use of color and ornamental decoration he discovered
in these areas and began to collect objects on his
journeys including fabrics, clothing, ceramics,
and sculptures.

Many fabrics show up again and again in Matisse's
paintings, one in particular being from a swatch that
he saw while riding a bus and hopped off to purchase.
This swirling, floral fabric in different shades of
blue was present in many of his interior scenes—
draped over tables, hung up in an attempt to mimic
wallpaper, and mixed and matched with other fabrics
and rugs.

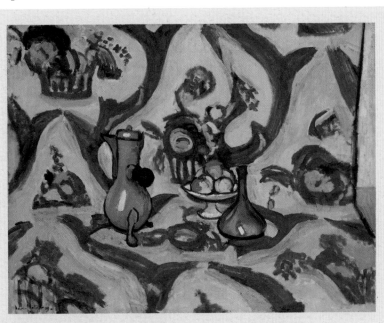

STILL LIFE WITH BLUE TABLECLOTH
1909, Oil on canvas

ABSTRACTION

Having already experimented with simplifying the subjects of his paintings, the interlacing and winding arabesque patterns of Islamic fabrics inspired Matisse to further experiment with abstraction. In *Interior with Eggplants*, Matisse captures the patterns in the scene with bold brushstrokes and color, painting them as they would have appeared flat.

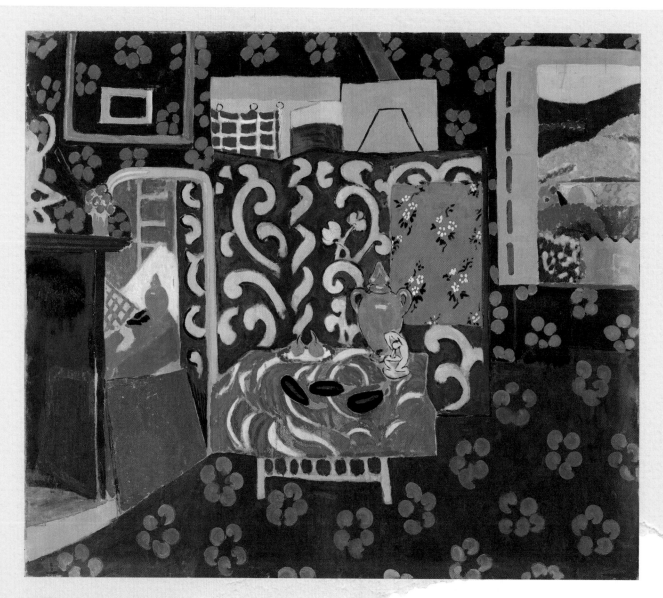

INTERIOR WITH EGGPLANTS
1911, Oil on canvas

Here, I have taken an intricate
pattern and recreated it using
simplified strokes and pure colors.
Try this simplification technique
for yourself on the next page.

Reimagine this pattern
in big, bold strokes.

Using the same pattern as a starting point, abstract it even more
to create something that is almost unrecognizable from the design
you have created opposite. Add your own interpretation by varying
the size of the motifs, using different media such as pencils or
pastels, changing the colors, and adding your own flourishes.

MOTIFS

Starting with these different images, make your own pattern
around each one by repeating and rotating it. Think back to
the earlier experiments with color. How can you use different
color combinations to make the pattern work cohesively?
Complementary colors will add vibrancy, while a monochromatic
palette will create harmony in your pattern.

For example:

On this page, make your own collection of motifs to draw on for future inspiration. Whether it be a piece of fruit, an unusual shape, or a favorite possession—let your eye settle on anything that piques your interest. Consider form, colors, scale, and shape.

Select one of your motifs and create a pattern by repeating, mirroring, or diagonally stacking it. Remember that you are looking to repeat your motif so keep your spacing relatively consistent and try to find a way to make the whole cohesive. Don't worry about accuracy: Matisse would have composed his patterns freehand.

The arabesque patterns Matisse was fascinated by
also allowed him to experiment further with color.
In *Still Life with Pomegranates*, Matisse uses black
and white to create negative space and provide
harmony to the other bright color combinations.

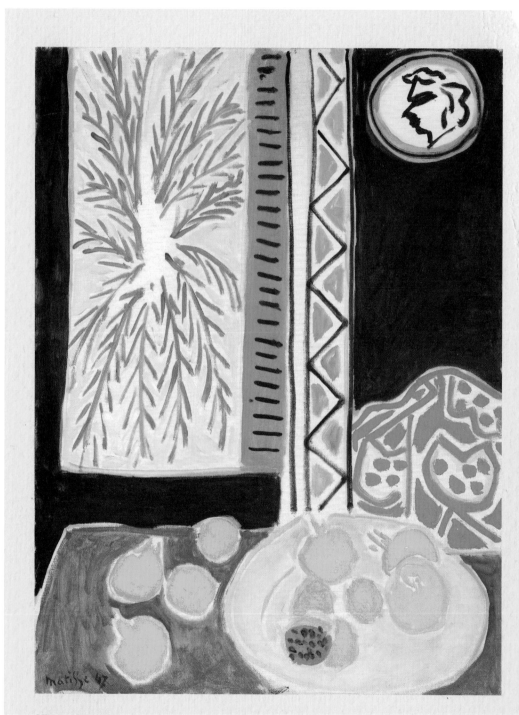

**STILL LIFE WITH
POMEGRANATES,**
1947, Oil on canvas

Fill in some of the shapes in this
pattern with colors and leave some of
them white. Think about how the black
background and white spaces impacts
the saturation of the colors.

PATTERN LANDSCAPE

In his still-life and interior paintings, Matisse mixed patterns
on every surface he could imagine—wallpapers, tablecloths,
rugs, and upholstered furniture with fabric draped over it.

Create your own pattern landscape on these
pages. First, make a drawing of the outlines
of the different features in your room. Taking
inspiration from Matisse's pattern mixing, fill
in the different areas with colorful patterns—
either ones that are present in your room or
from your imagination.

"

WHAT I DREAM OF IS AN ART OF BALANCE, OF PURITY AND SERENITY

"

HENRI MATISSE

INSIDE

Matisse worked in several different studios in
his lifetime—in the North of France, in Paris,
and eventually in the South of France in Nice,
overlooking the Mediterranean. He stayed for weeks
or even months at a time when visiting Morocco
and Spain, and there he settled in to create
several paintings and sketch out ideas having
visited museums and cultural sites.

Matisse often painted his different indoor spaces,
and he included objects he had collected from his
travels—usually ceramic vases, small sculptures,
fruit, flowers, and frequently a piece or two of his
fabrics draped or hung on a window frame or a surface.
Through these paintings we can trace his various
studios and visit the places he lived.

In this chapter we will look at how to create a still-
life scene and explore some of the objects and motifs
that Matisse returned to time and time again in his
paintings of interiors.

STILL LIFES

The fruits in Matisse's still lifes are often painted
simply, with bold colors.

Find some fruits from your own home and turn each one around
in your hand. Notice their texture and observe how they appear
from different angles. Recreate the forms through gestural tone.
Use broad marks made with a crayon or colored pencil,
focusing not on the outline but the mass.

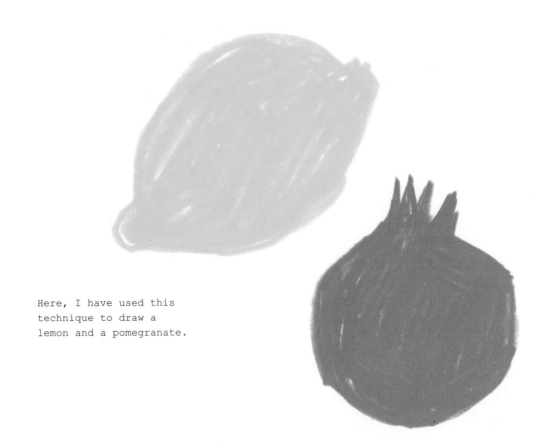

Here, I have used this
technique to draw a
lemon and a pomegranate.

Matisse wasn't concerned with making objects look
realistic but used them as a vessel to convey
emotions and to experiment with pure color.

Recreate the photos shown below, using the example to guide you.
Rather than starting with an object, you might decide to begin
with a feeling. For example, a horse might make you think of
speed, elegance, or a child's rocking horse. Shells might remind
you of beach walks or places you have visited. See how you can
capture the feeling each object gives you through a handful of
strokes and one color. Consider angle, pose, and palette.

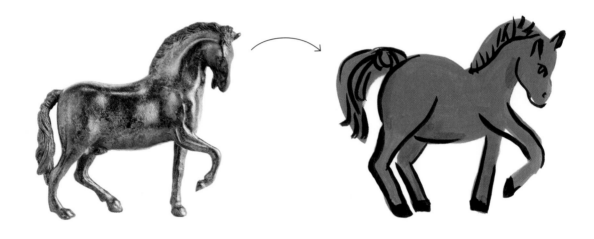

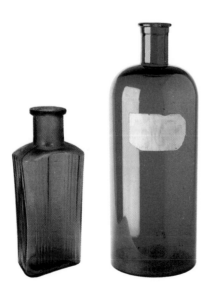

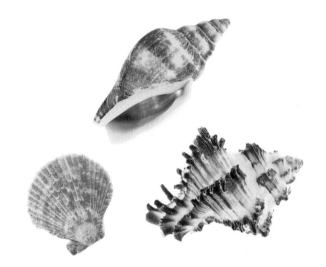

Do you have any objects that you've
collected from places you've traveled
to? Place some of them in front of you
and practice drawing them.

How did you feel when you collected
these objects? Use color to help evoke that
feeling. Maybe you felt content—if so, use
shades of light blue. If you felt excited
use complementary colors such as orange and
blue, and if you felt melancholy, try darker
shades of blue.

Pottery and ceramics from China and Japan
are another common motif in Matisse's work.
These were decorated in blue with scenes
including trees and floral patterns.

Recreate the pattern
on the vase in
the photo, using
simplified strokes.

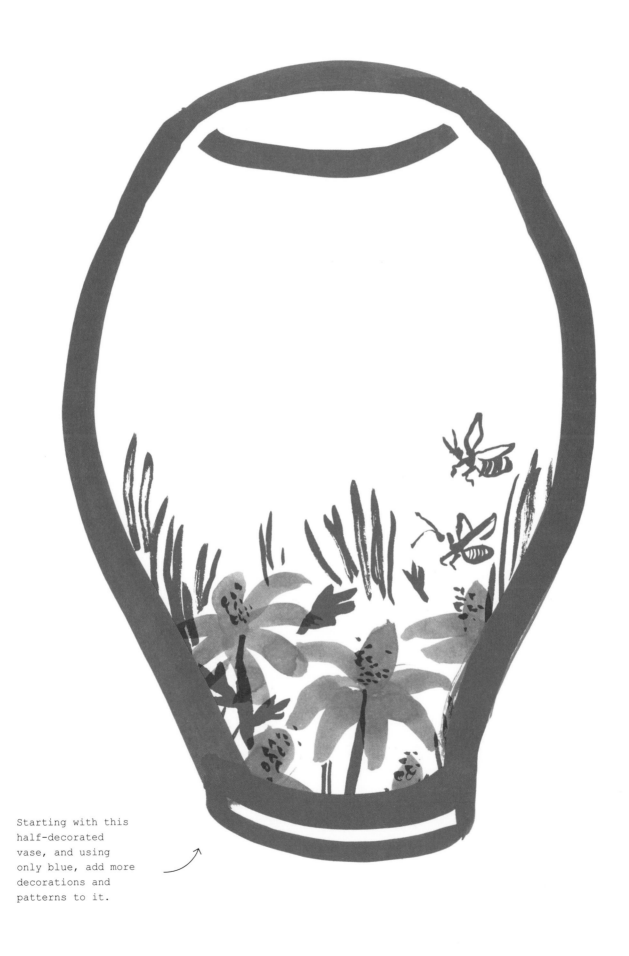

Starting with this half-decorated vase, and using only blue, add more decorations and patterns to it.

Matisse also experimented with creating depth and dimension in
his still-life paintings. Looking again at fruits you have at
home, notice the different areas of light and shadow you can
see on each one, from the lightest highlight to the darkest
area, and the subtle transitions in between.

You can use a single colored pencil or crayon to convey some
of these differences: if only a little pressure is applied,
a lighter shade will be achieved, while pushing hard or
repeating a stroke over and over in the same place will
create a darker tone.

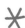 For the more concentrated areas of shadow and for
shadows underneath your fruit, add darker colors—
but remember that these don't have to be black or
gray—many shadows are blue or purple in tone.

Matisse draped and folded fabric in his interior and still-life scenes to further play with the way patterns mixed and influenced each other. In *Still Life with Apples on a Pink Tablecloth*, you can see how Matisse has shaded in the creases and allowed the pattern to be cut off in places where it was folded over, to convey the folds and weight of the fabric.

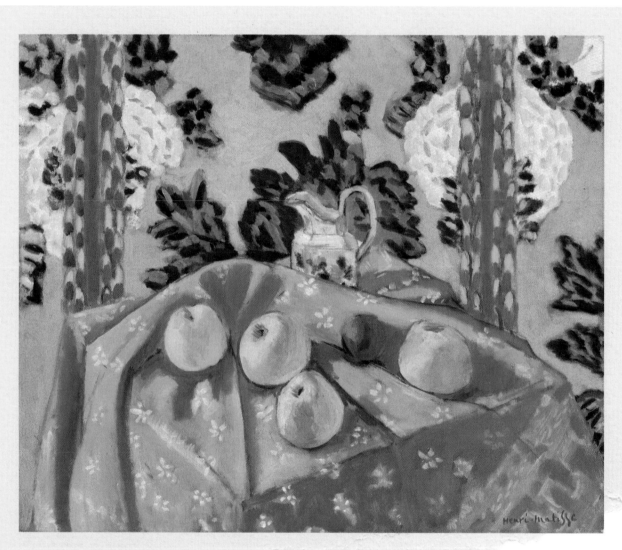

STILL LIFE WITH APPLES ON A PINK TABLECLOTH
1924, Oil on canvas

To try this for yourself,
lay a piece of fabric over
an object with some height.
Here, I have covered a
vinegar bottle in a
printed scarf.

Arrange the drapes in your fabric so they are
dramatic, and draw what you see. Notice how the
pattern travels across the parts on the outside and
the folds on the inside. Pay attention to which parts
are in the shadows and which parts are in the light.

Still-life drawing is a great opportunity to practice composition. The artist can arrange their subjects any way they choose and can include anything they like.

Select a few objects you use every day and lay them on a table in front of you. Consider height, line, shape, and light, as well as their function and texture. Try to include a variety of forms and practice drawing each piece separately on these pages.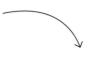

First, look carefully, paying particular attention to the
shapes of your objects. Hold each edge or shape in your mind
and if you need to rehearse it, apply light pressure with
your pencil. Then use a bolder, heavier line when you're
ready to set the line in place.

* When drawing a bowl or a pan avoid hard
 edges in favor of loose elliptical
 marks, communicating its contours.

When Matisse arranged his
compositions, he paid just as
much attention to the negative
space around the objects as he
did to the objects themselves.
Drawing the space around a
still life is a useful exercise
that will help you break
down preconceived ideas about
what you see. Using these
instructions, try this exercise
in the space opposite.

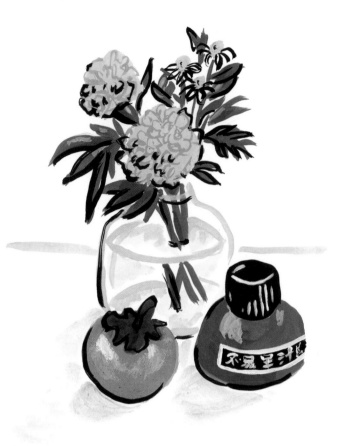

1) Arrange a still
life using some of the
objects you've chosen.

2) Draw the outline of your
arrangement, thinking about
the shapes the edges of your
objects make. Then, shade in
the negative space.

Before painting his *Still Life with Seashell on Black Marble*, Matisse created cut-out paper versions of the objects he was using, pinning and rearranging them until they took a form that pleased him. This allowed him to try out different arrangements and achieve balance in his final composition.

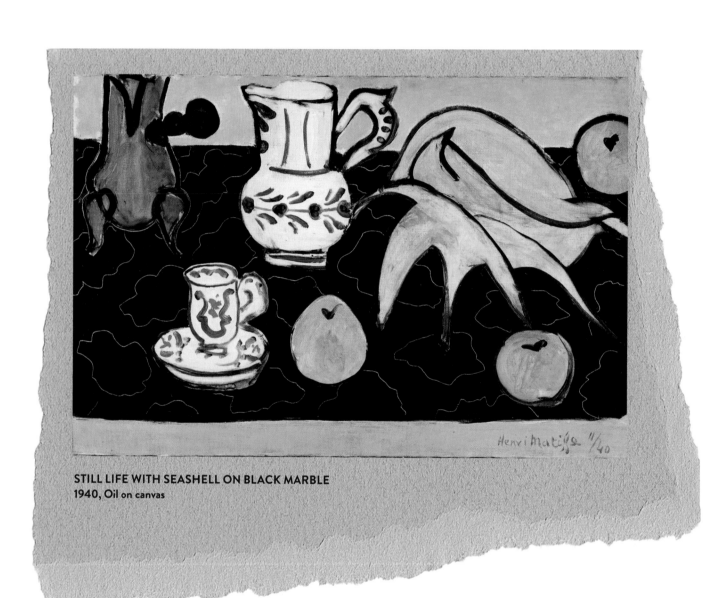

STILL LIFE WITH SEASHELL ON BLACK MARBLE
1940, Oil on canvas

Cut out the shapes of the
objects you've chosen for your
still life. These can be rough
drawings or cut out of colored
paper. Use the next page to
experiment with their placement.

* Placing some of the objects so that they overlap
 or are just touching each other will help to
 form connections that lead the eye around your
 composition. If you have a vase or an ornament
 with an interesting shape, try leaving space
 around it to heighten its impact.

Try one arrangement of your cut-outs, and use sticky tack to
fix it in place. Come back the next day. How do you feel about
your design today? Rearrange the objects into a new formation,
and consider the negative spaces. How does it change the tone
of the image when objects are placed on either end of the
page versus when they are clumped together?

Now use colored pencils or pastels to create your
final still-life picture.

Remember that the colors you use don't have to be realistic.
Look at your objects and think about what you want to emphasize
about each one—whether that is its pattern, color, or shading.
Think back to the earlier exercises and use the techniques
you've developed to help you communicate these qualities.

CHAIRS

In addition to collecting fabrics and ornaments to use in his paintings, Matisse used a variety of chairs.

Scouring your home for as many seats as you can find, notice the different styles and ranges in design. Walk around and sit on each chair. Where does the form narrow and where is it widest? Is it tall? What is its most definitive feature?

Draw your chairs here, using no more than ten simple lines to capture their design and shape.

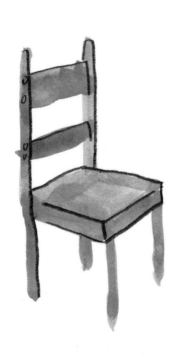

"Art should be something like a good armchair in which to rest from physical fatigue."
HENRI MATISSE

For Matisse, objects were not lifeless or static—to be seen in one way or for one purpose. One of the objects that Matisse returned to several times in different works was his Rocaille chair, which had arms carved as dolphins and an oyster-shaped back and seat. In the painting below, Matisse places this chair center-stage and focuses on its curving shapes, not containing the complete chair within the canvas.

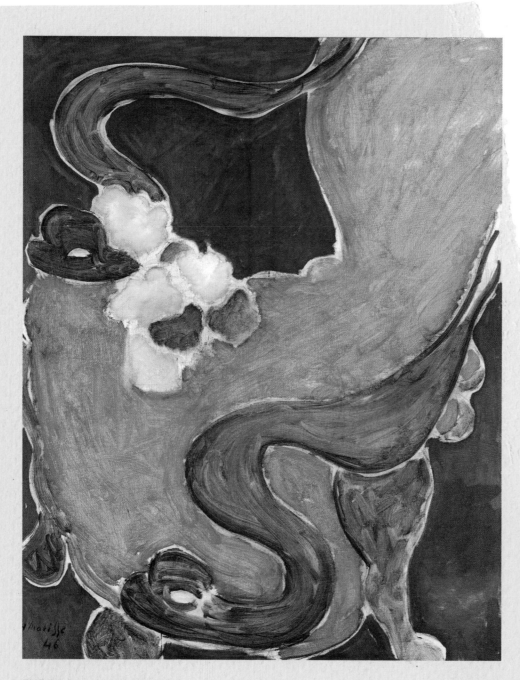

THE ROCAILLE ARMCHAIR
1946, Oil on canvas

Focus on a part of one of your chairs that has a particularly striking shape—perhaps the back rest, the arms, or the seat. Fill this frame with that detail, emphasizing the curves or lines that are most interesting to you.

Matisse was also fascinated by the beautiful shell details
of his Rocaille chair. Choose one of your chairs with an
interesting texture. Does it have intricate wooden patterns
or textured fabrics? Using these prompts, draw each part of
your chair on these pages, this time focusing on the texture.

CHAIR LEG

FOOT

CUSHION

ARM

BACKREST

Chairs play a part in our everyday lives, and an empty
chair can often denote a presence. Do you have chairs
that you particularly associate with people you know?
Draw these seats here to create chair "portraits".

Use colors that remind you of each person, and add objects that are connected with them—such as a musical instrument or a piece of clothing—onto or next to the chair, to further suggest your subjects' personalities.

When Matisse painted interiors, he often used flat planes of colors and played with spatial dimension in a novel way. He took inspiration from Japanese woodblock prints, which comprised many layers of flat colors with the key image printed in black. In *Red Room (Harmony in Red)*, the chairs and table act as a navigational reference points, anchoring the space and helping to define the composition.

RED ROOM (HARMONY IN RED)
1908, Oil on canvas

There is also a visual game afoot: is that a window or a picture to the left? We can probably assume it is a window because of the chair leaning up against it. This detail and the difficulty of identifying a centerpoint—the focal point of the work—holds the viewer's attention and demands a closer look.

Create an interior composition of your own. First, draw
the features of the room, and include chairs. Then
fill in the surfaces with different colors. Whenever
possible, use large areas of flat color to create tension
between the different elements in the scene.

IN THE STUDIO

In his studio paintings, Matisse often included
miniature abstracted versions of paintings and
drawings he was working on. He used paintings
of his studio as a method of self expression,
spelling out his program and identity.

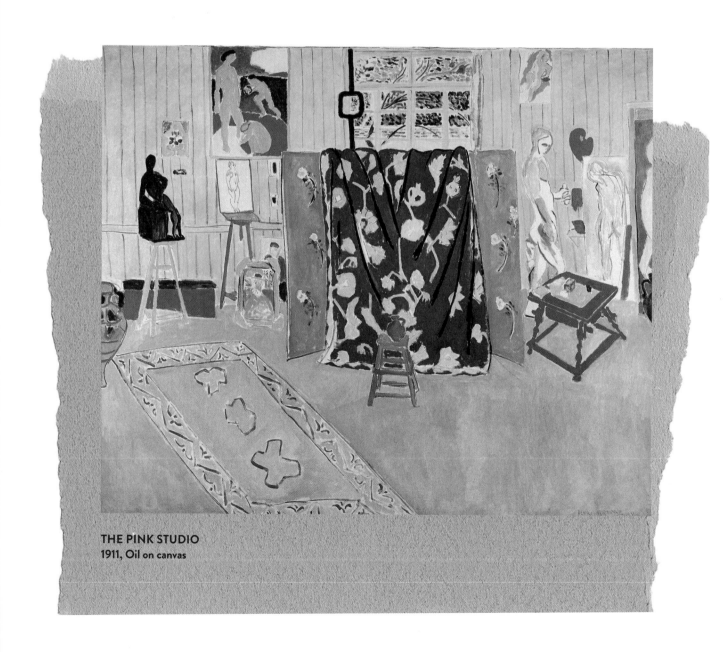

THE PINK STUDIO
1911, Oil on canvas

Fill the frames in this imaginary workspace
with miniature depictions of the images you've
already created in this book or try recreating
your favorite artworks using the techniques
we've explored so far.

Where do you like to draw or work? Sit in a different part
of your workspace so you can draw your desk. Include half-
finished drawings and all the tools you are using to give
the viewer an insight into your creative process.

While Matisse's studio space may have been real, his
interpretation of it wasn't always. In *The Pink Studio*, he
filled the walls with rich tones of red and pink, hoping to
make the room feel the way it felt to him.

Use this space to draw your ideal studio. Reimagine your environment in
colors inspired by Matisse. Think about which furniture is needed—add
shelves for collections and books, and a surface or an easel to work on.

OPEN WINDOWS

A recurring motif in Matisse's paintings was the open
window, which he painted both as a background detail
and the main focus of his canvases.

In *Landscape Viewed From a Window*, Matisse uses muted
shades of blue and varying tones of tan, pastel
yellow, and white to give the scene a calm feeling.

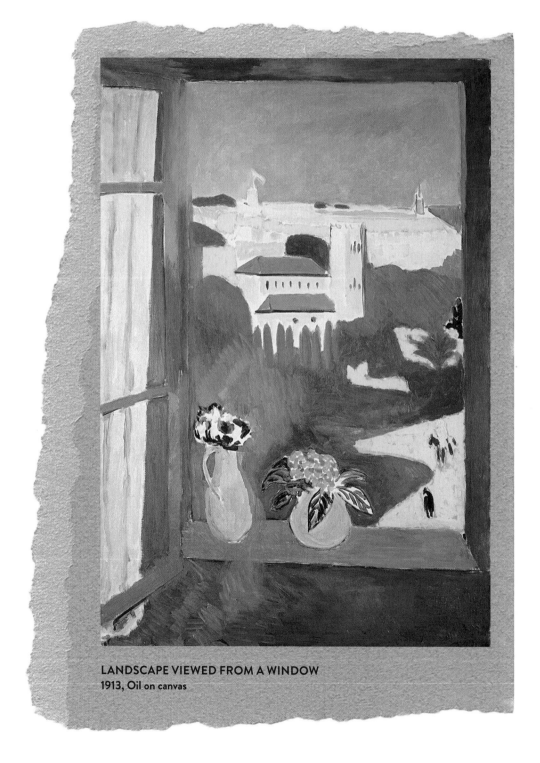

LANDSCAPE VIEWED FROM A WINDOW
1913, Oil on canvas

In *Open Window, Collioure*, Matisse uses
bright, solid colors to create energy
and contrast between the interior scene
playing out in front of the window and
the exterior scene outside of it.

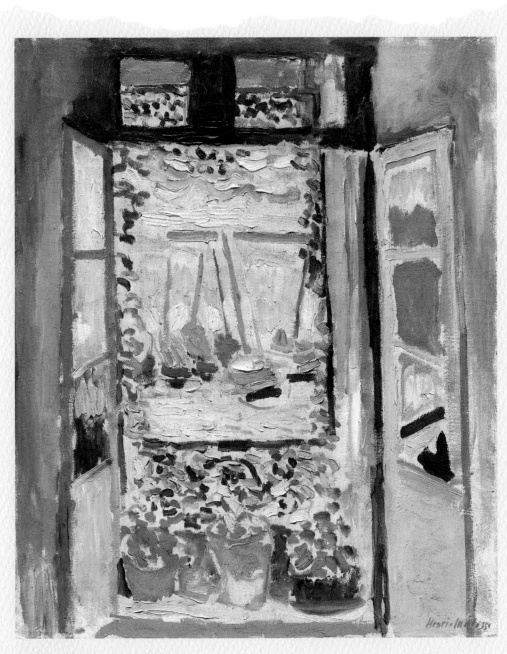

OPEN WINDOW, COLLIOURE
1905, Oil on canvas

What can you see outside your window right now? Are there trees or animals? Pick a window in your home and draw the frame and the view outside of it. Use colors close to each other on the color wheel to create harmony between the interior and exterior.

Taking inspiration from *Open Window, Collioure*, and looking through a different window, use multiple colors to evoke your reaction to the scene that you see outside. Experiment by filling some areas in blended areas of pure color, and use short strokes to build up color in other areas, to vary the rhythm of your work and create energy.

Imagine a landscape that is completely different from where
you live. If you live in a city, try picturing a forest.
When depicting a tree, a Fauvist might see green leaves and
a brown trunk, but will interpret it with blue leaves and
a red trunk. Remember what you've learned about expression
and complementary colors and apply it to the scene outside
of this window.

 Decide whether there should be anything
in front of the window (a table with
a bowl of fruit, for example).

 Think about the room that this window is in. Are there patterns on the curtains? Wallpaper on the walls? Extend your drawing onto this page, adding details to the room.

"

I HAVE ATTAINED A FORM FILTERED TO THE ESSENTIALS

"

HENRI MATISSE

CUT-OUTS

Towards the end of his life, Matisse was often confined to his bed or a wheelchair. With this limitation in his mobility, he began to create paper cut-outs—shapes cut from brightly colored sheets of paper that he would arrange and pin down with the help of some studio assistants. Deceptively simple in appearance, with their bright and bold shapes and swaths of color, they were not simple in concept. All of his ideas about color, pattern, and ornamentation were finally consolidated in one form of working.

Rather than create a shape with a brush, Matisse could create a shape of pure color using scissors, enabling him to move the shapes around before settling on their final layout. It was a new manifestation of his theory on the use of pure color, simplified to work with this new method of making art. This way, he could play with color, shape, and pattern in a more flexible way.

JAZZ

Matisse created and illustrated many artists' books in his lifetime, but *Jazz* consisted of his own writing and collaged paper cut-outs. The book isn't really about jazz music: it was inspired by the circus and Matisse's travels. He discovered in his method of collage a similarity to the improvisational aspect of jazz music and felt he was creating these collages in the same manner—spontaneous, bright, and energetic—and thus the title was selected.

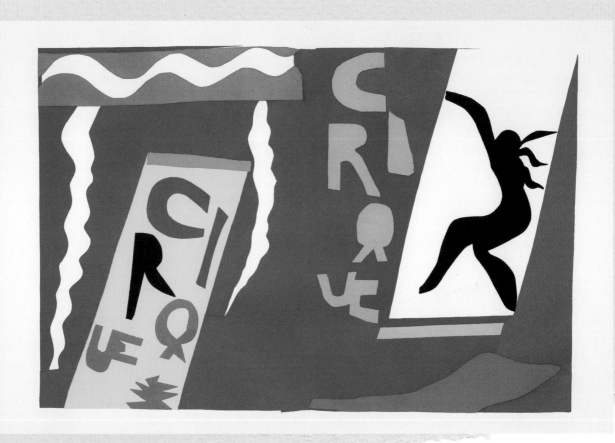

THE CIRCUS, plate II of the 1947 illustrated book *Jazz*
1947, Pochoir

Matisse didn't spend a long time cutting out
shapes, but rather improvised as he went, allowing
the scissors and his hand to decide the shapes.
His cut-outs were simple and abstracted from the
objects they were meant to represent.

You can simplify objects into just a few cut-out
pieces. Here, I have made some examples using
everyday objects.

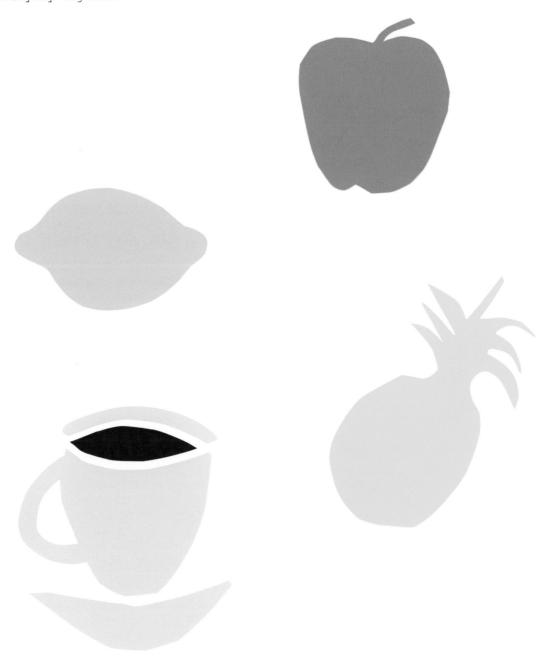

Use colored paper to make cut-outs of these subjects,
simplifying them down to their silhouettes. Instead of
planning out each shape before you cut by drawing it
onto the paper, think of the process as sculpting with
your scissors and use your eye to guide you.

CAT

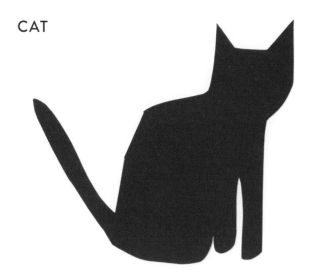

GUITAR

HORSE

Think about the characteristics and shape of each image—
can you make them recognizable if you use a completely
different color from what they're supposed to be?

BIRD IN FLIGHT

FISH

TREE

Jazz includes lots of images of circus performers in motion, leaping and dancing through their scenes. Matisse felt an affinity with these subjects; he said that cutting out shapes made him feel like an acrobat or juggler, so concentrated on the task that was in his hands. In *The Swimmer in the Aquarium* plate from *Jazz*, the diagonal pose adds drama and holds the focus of the viewer.

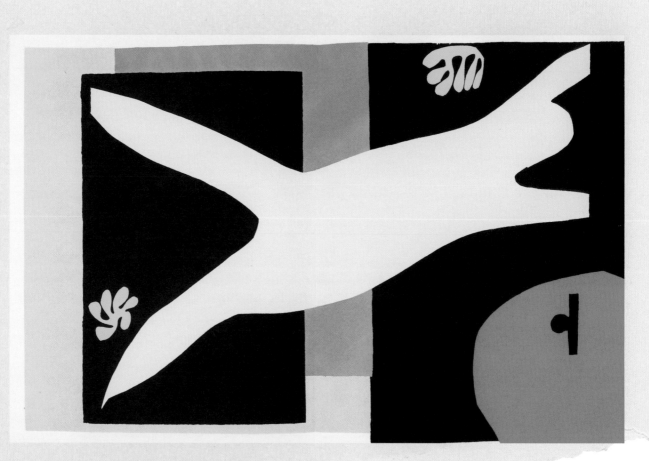

THE SWIMMER IN THE AQUARIUM, plate XII
of the 1947 illustrated book *Jazz*
1947, Pochoir

Here, I have created collages
of figures in motion, using
diagonal angles and contrasting
perpendicular lines to create a
feeling of movement.

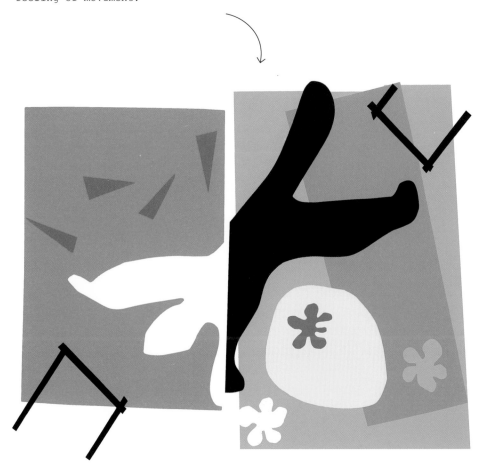

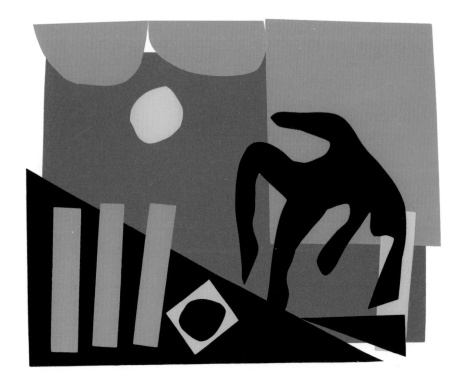

Using the prompts below, create cut-outs
of each action. Think about how you can
use shapes, composition, and placement
to suggest movement.

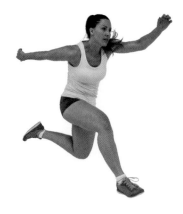

RUNNING

WALKING

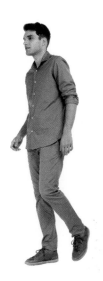

DIVING

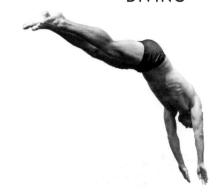

SPINNING

"He who loves, flies, runs, and
rejoices...is free and nothing
holds them back"
HENRI MATISSE

Instead of the different pages in *Jazz* fitting together like a single narrative, each tells its own story. Matisse chose the necessary elements to reference the story or the figures he was using. This plate from *Jazz* depicts the mythological figure Icarus who flew too close to the sun.

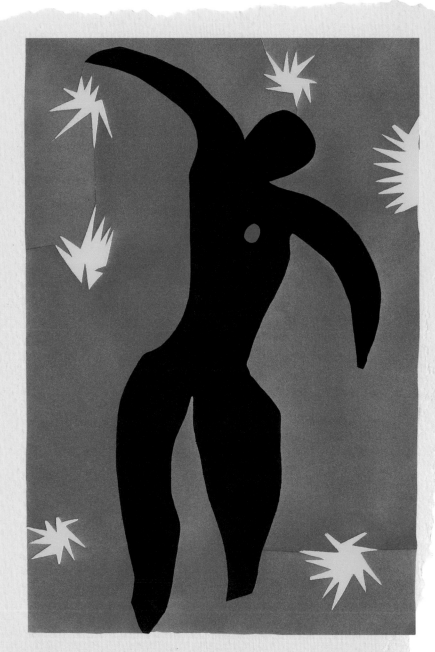

**ICARUS, plate VIII of the 1947 illustrated book *Jazz*
1947, Pochoir**

Choose one of your favorite fairy tales, poems, or books and summarize your story in one sentence, reducing the story to its key theme or plot line. Now consider how that might manifest itself through shape, color, and form.

FLORA & FAUNA

Having painted a plethora of flowers in vases and potted
plants throughout his life, Matisse still had a fondness
for depicting the natural world in his cut-outs. One of the
shapes he used was a blobby leaf, seen below in *The Sheaf*.
Cut out in a variety of colors and sizes, this shape appeared
throughout his cut-paper collages.

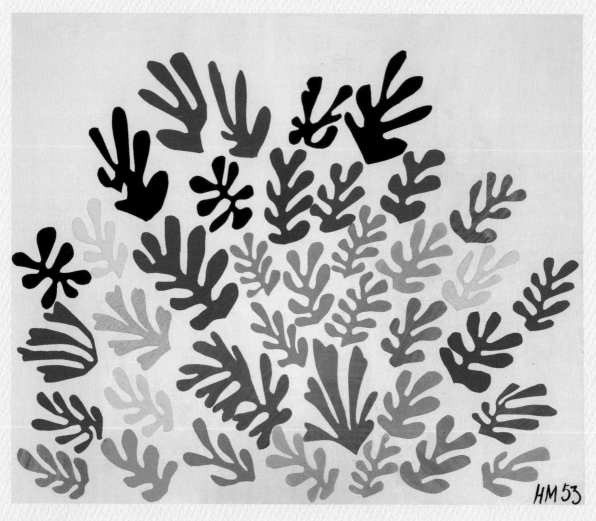

THE SHEAF
1953, Gouache on paper mounted on canvas

Consider how the pieces of a flower fit together like
a jigsaw puzzle. Here is an example of a cut-out
made using a lily for inspiration. Using different
colored papers, I have cut out simplified versions
of each part of the flower and arranged them on
the paper.

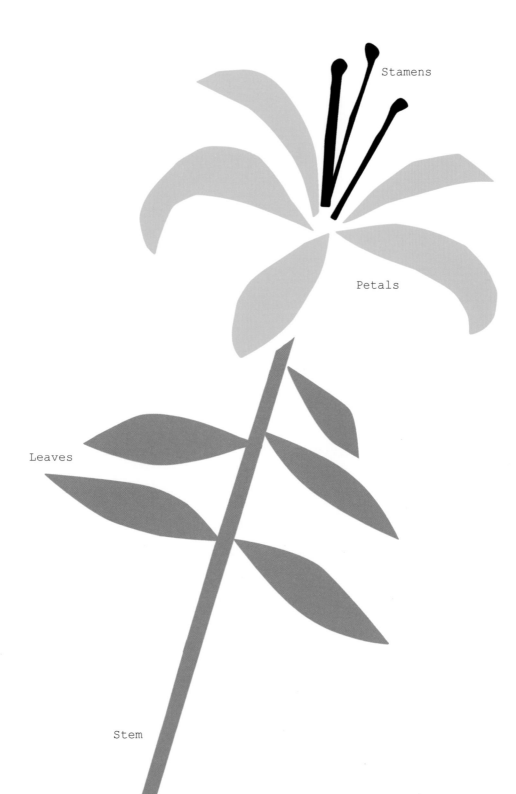

Stamens

Petals

Leaves

Stem

Do you have any houseplants, flowers in vases,
or plants around of your home? Make cut-outs of
them, using as few cut paper pieces as possible.
Look at the stem, leaf shape, and petals, and
simplify each of these shapes before arranging
them as a collage.

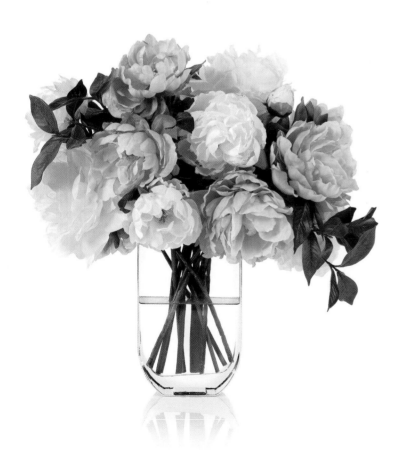

Matisse often created cut-out patterns to be used in
buildings, and to decorate walls or windows. He took
inspiration from the patterned tiles he saw (and sometimes
collected) that decorated buildings on his trips in Spain
and North Africa.

Here, I have created a tile design using just a few
repeated shapes cut out in different colors.

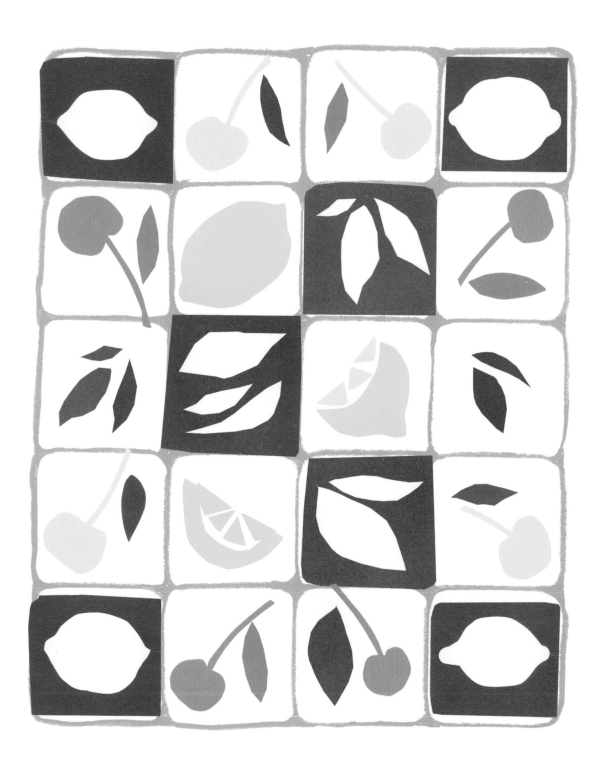

Make a tile design for a room in your own house.
First, create several of your own cut-out motifs.
Cut out the same shapes in different colors and use
them to decorate this empty tile template.

When Matisse's health prevented him from walking
outside, he created a collaged scene on his walls
inspired by nature, and called it his garden.

Using these flower and leaf shapes as a starting point,
imagine a beautiful garden scene, and create cut-out motifs
of the plants, animals, and birds you would see there.
Arrange your shapes as though they were blossoming out
toward the edge of the page.

Years after traveling to Tahiti, Matisse recalled his
voyage with delight, finding himself more inspired by
the memory of the place than when he was there. He
created a series of cut-outs that looked almost like
textiles—very bold, patterned, and with a border
along the edges—to recreate his memories of it.

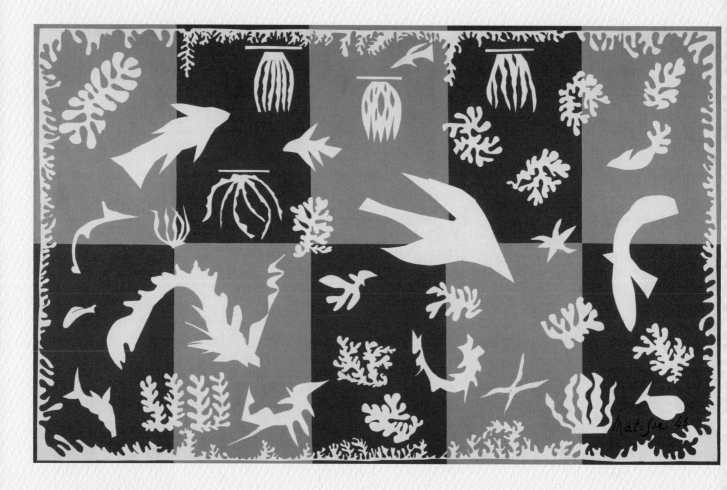

POLYNESIA, THE SEA
1946, Gouache on paper cut-out

Using this grid, create your own cut-out collage based on a
memory you have or a place you have visited. Were you in a
city or in the countryside? What did you see, hear, and smell?
Fill each rectangle with a solid color, and add cut-outs to
recreate your experience. Imagine how your design would work
as a functioning blanket or textile, where there is no correct
orientation from which to view it.

FIGURES

Matisse abstracted the human figure in a series of cut-outs, the *Blue Nudes*. He used multiple shapes of paper to create forms—for example, an arm could be cut out as one soft v-shape, or it could be made of two rectangular shapes pieced together to make a v. Matisse tried out different placements of the shapes, pinning them in different positions many times until he reached his final arrangement.

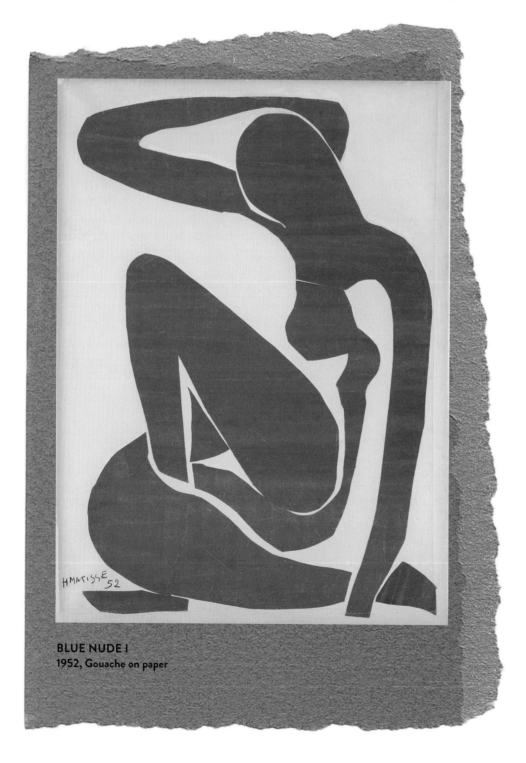

BLUE NUDE I
1952, Gouache on paper

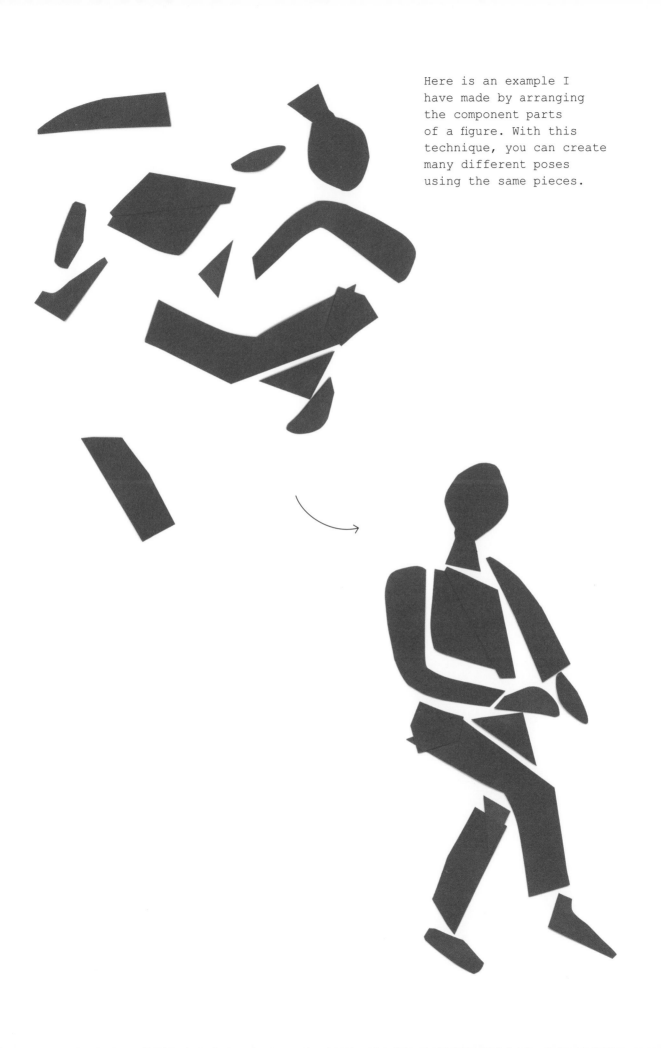

Here is an example I
have made by arranging
the component parts
of a figure. With this
technique, you can create
many different poses
using the same pieces.

Using multiple cut-outs of shapes to represent different parts of the body, create collages of the poses shown in the photographs. Reference the example on the previous page if you need help visualizing how to abstract a person, and sketch the figures in pencil to help you plan them out before you stick the pieces in place.

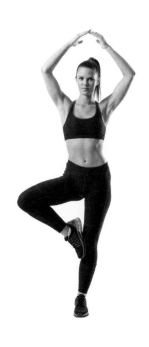

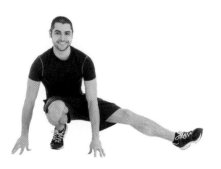

STAINED-GLASS WINDOWS

Late in life, Matisse created the stained-glass windows for a church, using his cut-out technique to design the windows before they were made. Having previously painted many scenes with open windows and the landscape outside of them, or the interior scene in front of them, this provided Matisse with a new challenge—the window itself. He filled the windows with his frequently used leaf shape in coordinating shapes and colors to symbolize its theme: the tree of life.

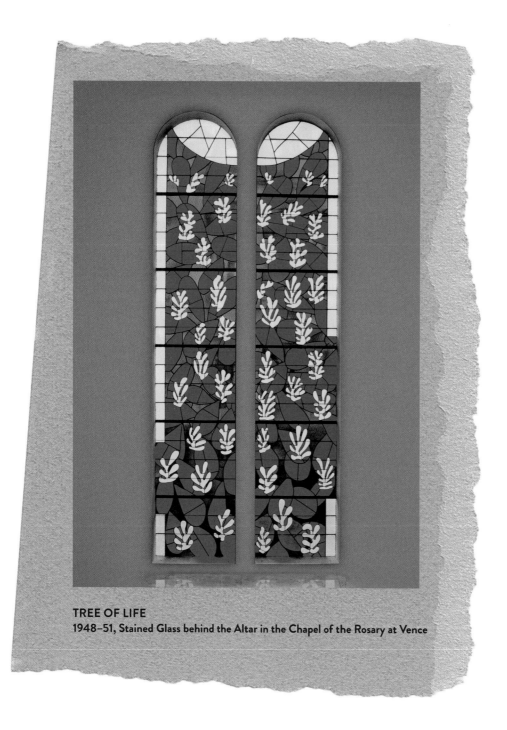

TREE OF LIFE
1948–51, Stained Glass behind the Altar in the Chapel of the Rosary at Vence

Create a window design to symbolize the theme of eternal spring.
Cut out different shapes you associate with this theme, and
arrange them in these frames. When choosing which colors to use,
consider how light would shine through each color and how it
would affect the room these windows are in.

Using these frames, now design stained-glass windows for your own house. Fill them with any forms you like—you could design an abstract motif to repeat, like Matisse's leaf shapes, or make shapes that would create a narrative.

Fill each window pane with a solid color before
sticking your cut-outs in place. If you're
creating a narrative, think about how it would
play out over each of the four windows.

ACKNOWLEDGEMENTS

An immeasurable amount of gratitude for their editorial expertise and help in realizing this book—Zara Anvari, Zara Larcombe, Francesca Leung, Rachel Silverlight, and Jenny Dye. And to Clay Hickson, who, with an astute mind and discerning eye, helped with the rest.

ABOUT THE AUTHOR

Liana Jegers is a writer and illustrator based in Los Angeles. She contributes a column to *The Smudge*, a monthly newspaper which she co-founded and edits. In addition to her personal practice, she regularly illustrates for various magazines, books, and websites.

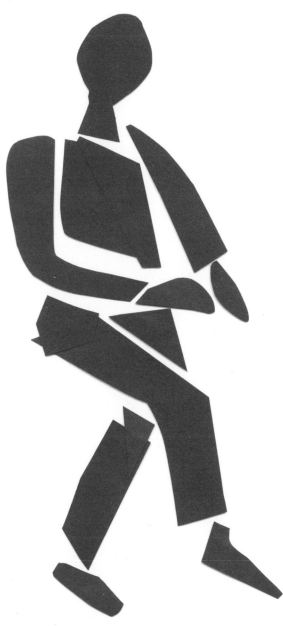